Adult Coloring Book Dragonflies
Vol 8
By: L. M. Boelz

I want to take a moment to thank you for purchasing this coloring book.

A lot of time went into the making of it. I wanted to be able to give you hours of fun and relaxation. So Enjoy. Be sure to check out my other coloring books if you like this one. There are 20 different pictures to color in this book.

Other titles see back pages for examples

Southwest, Floral

Chickens

Zen Eggs

Dragons Fantasy

Day of the Dead & Mardi Gras

Farm Animals

Arizona Summer & Desert Life

Copy Right July 17 2016

Please enjoy, be creative and think outside the box. You can color traditional or go wild with colors. The pages are one sided which allows you to frame them if you so desire. You can use pencils, markers or fine tipped pens. If using a marker or ink place something between the pages to prevent the color from bleeding through to the next page.

All Rights Reserved, Including The Right Of Reproduction In Whole Or In Part In Any Form.

This -Book Is Licensed For Your Personal Enjoyment Only. No pictures can be copied and resold, rented or least in any form. The Author Holds All Reproduction, Reprint Or Re -Sell Rights To This Book In Digital, Audio Or Print Versions.

pages

Terri…………………………………………………......…..	1
Kaylynn………..…………..………………………….……	2
Jazzmeen ……………………………………………….…	3
Malinda…………..………………………………………..	4
Kym………………………………………………............	5
Brenda……………………………………………………..	6
Claire…………….………………………………………...	7
Heather…………………………………………....………	8
Jennifer…………………………………………………....	9
Lona………………………………………………………..	10
Laurie…………….…..…………………………………….	11
Jackie ….…………………………………………………..	12
Jessie .……………………………………………………..	13
Mindy……………………………………………….……..	14
Misty…………………………………………………….…	15
Jay…..……………………………………………….……..	16
Nannette…………………………………………………..	17
Tiffany ……………………………………………………..	18
Bobby………………………………………………….…..	19
Lin…………………………………………………….…….	20

I would like to ask if you enjoy my coloring book please leave

a positive review on Amazon. It really does help. I have put a lot of time

and effort in doing my best to hand draw these for your enjoyment.

They may not be machine perfect, but that is the nature of hand drawings.

If you did not like the book, I am sorry I did not meet your expectations.

If you have suggestions of what type of coloring books you would like

to see in the future drop me a line. Would love to hear from you.

Linboelzadultcoloringbooks@gmail.com

Visit my webpage to see upcoming projects. linboelzadultcoloringbooks.weebly.com

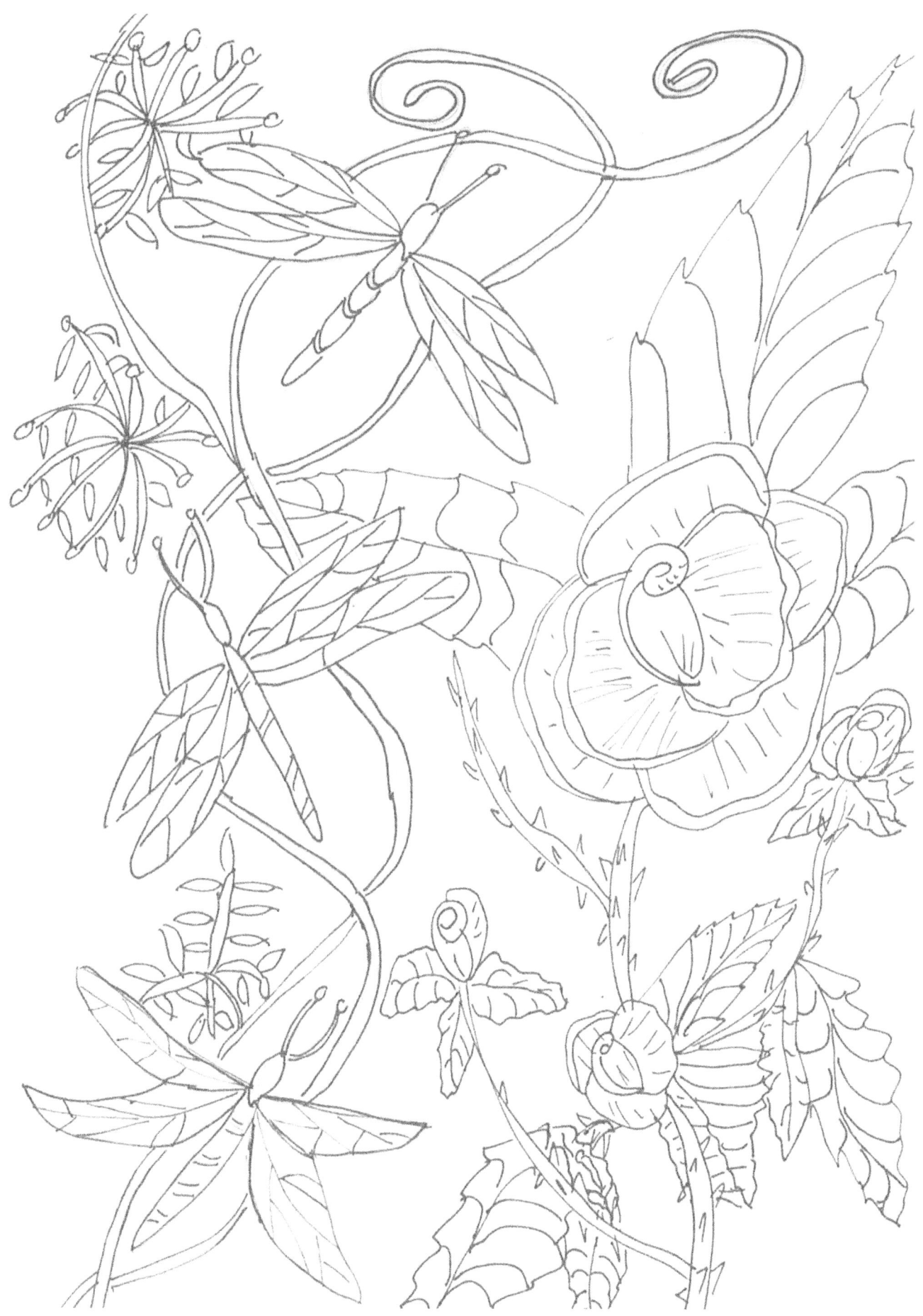

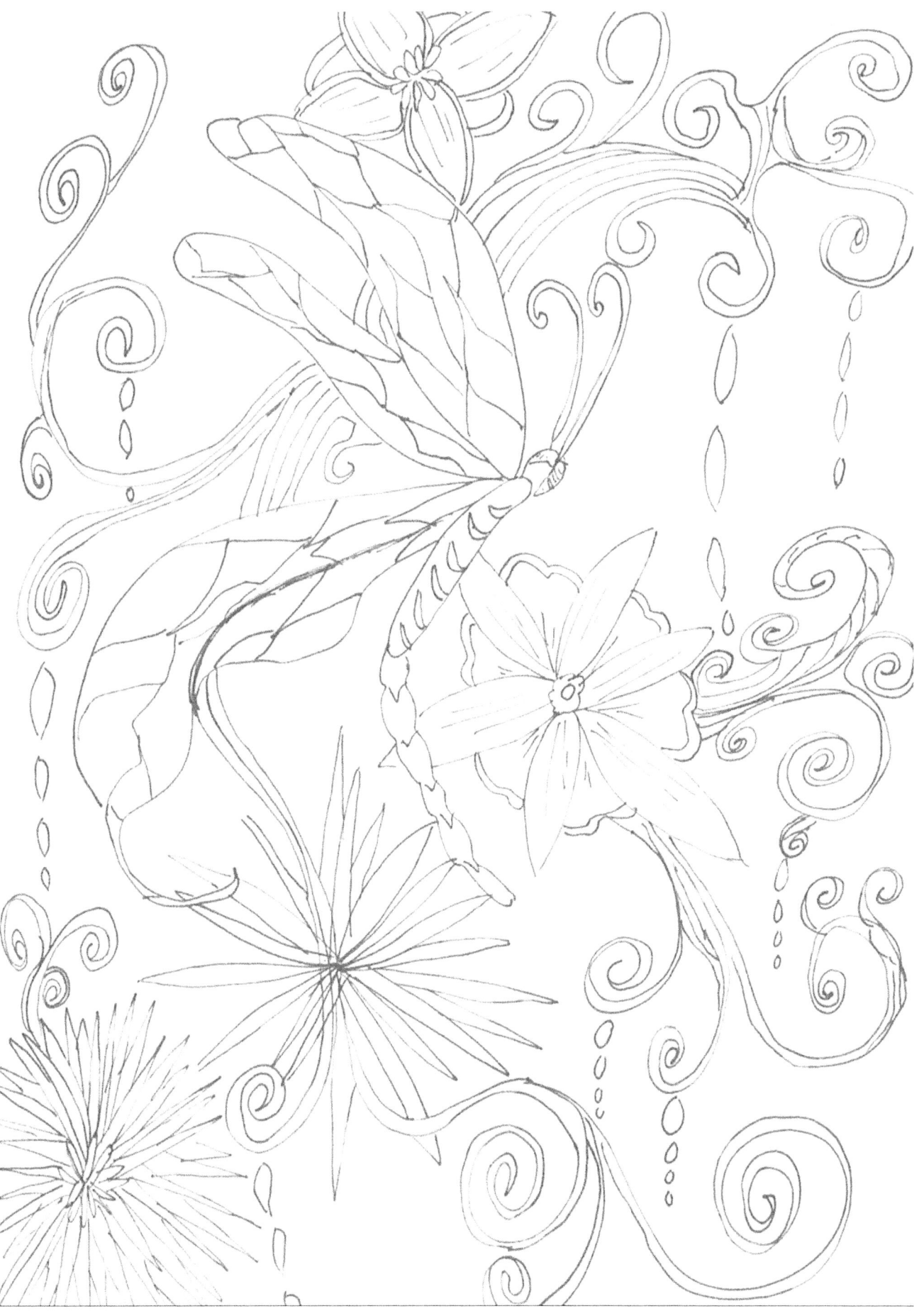

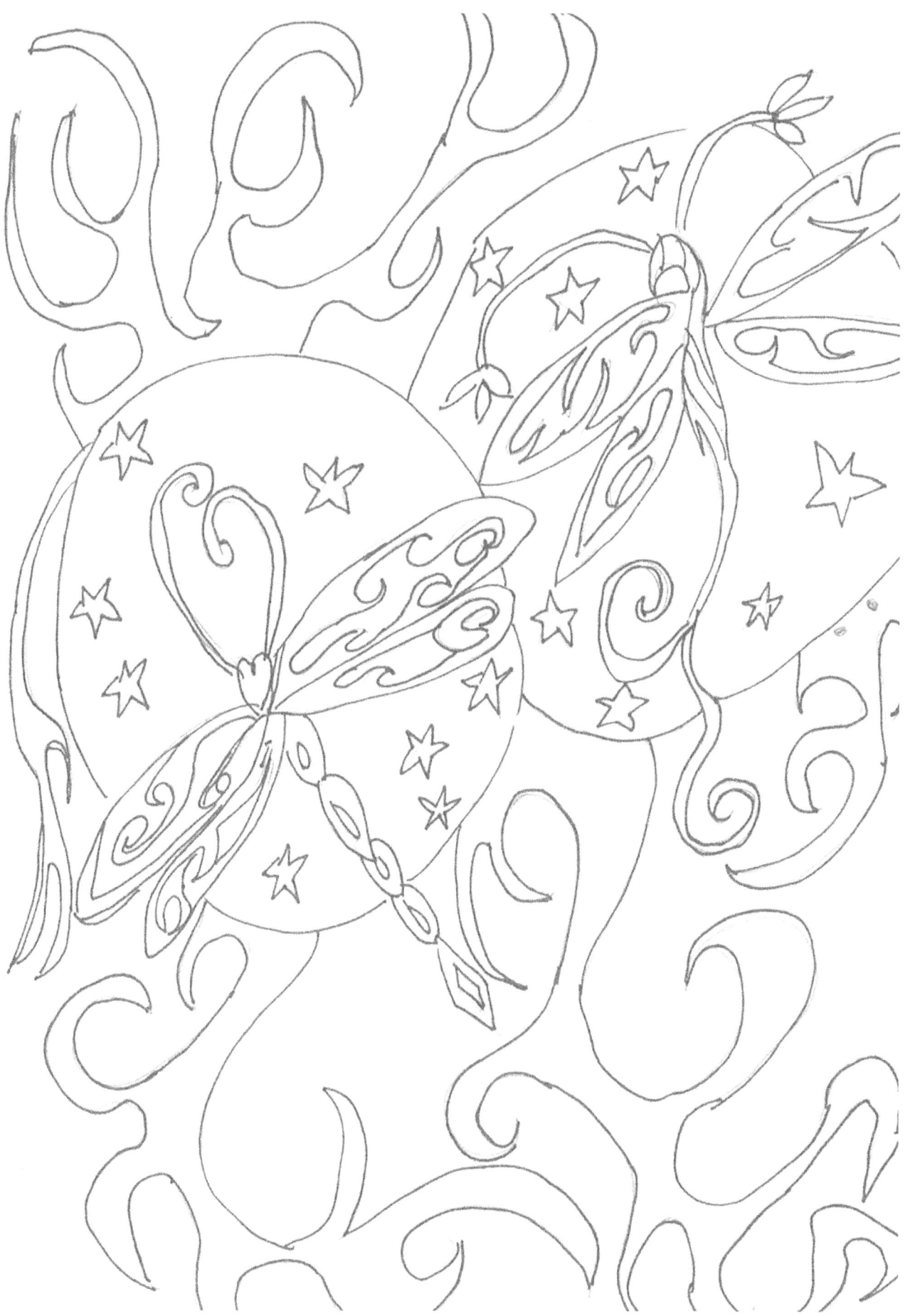

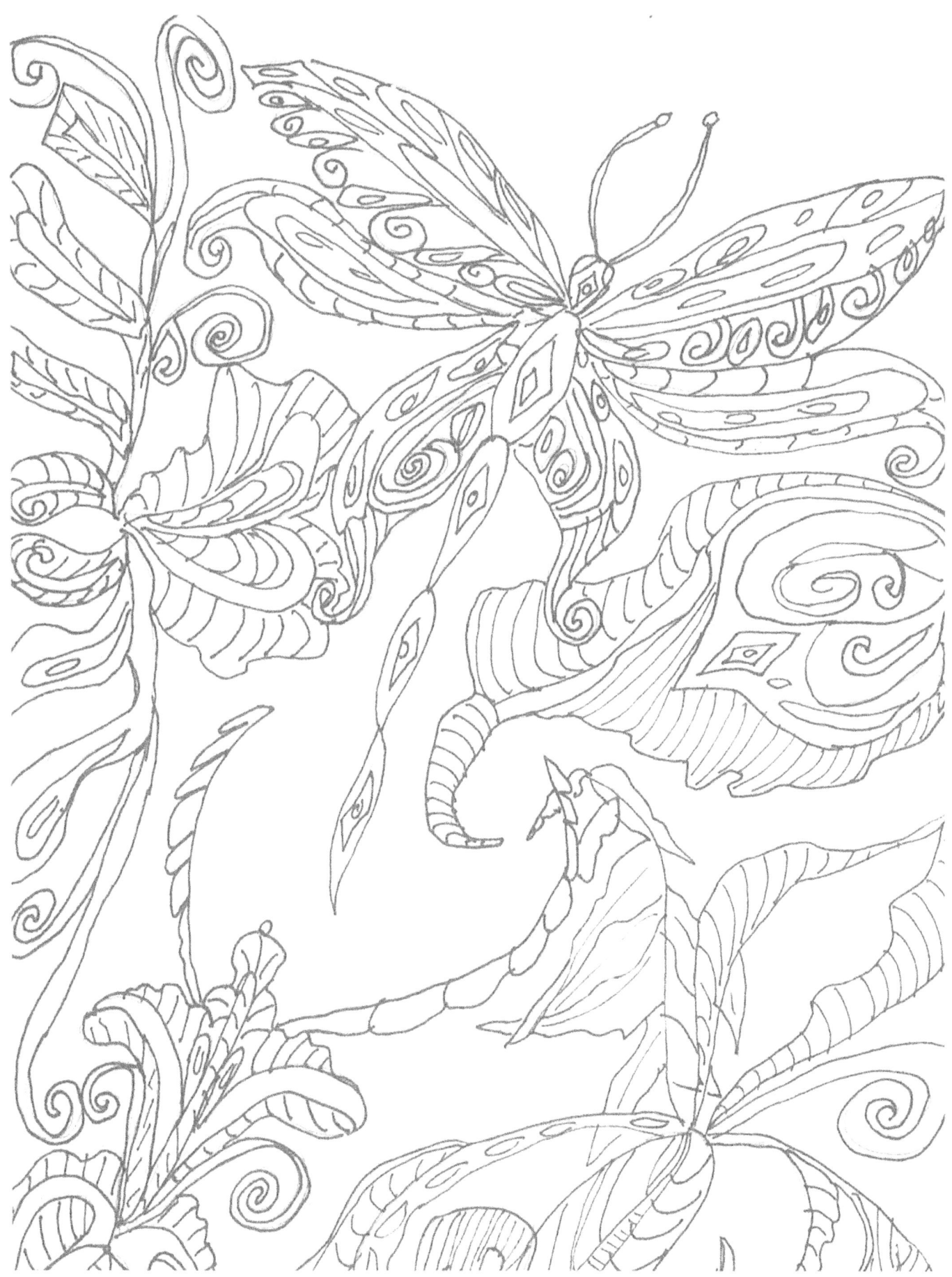

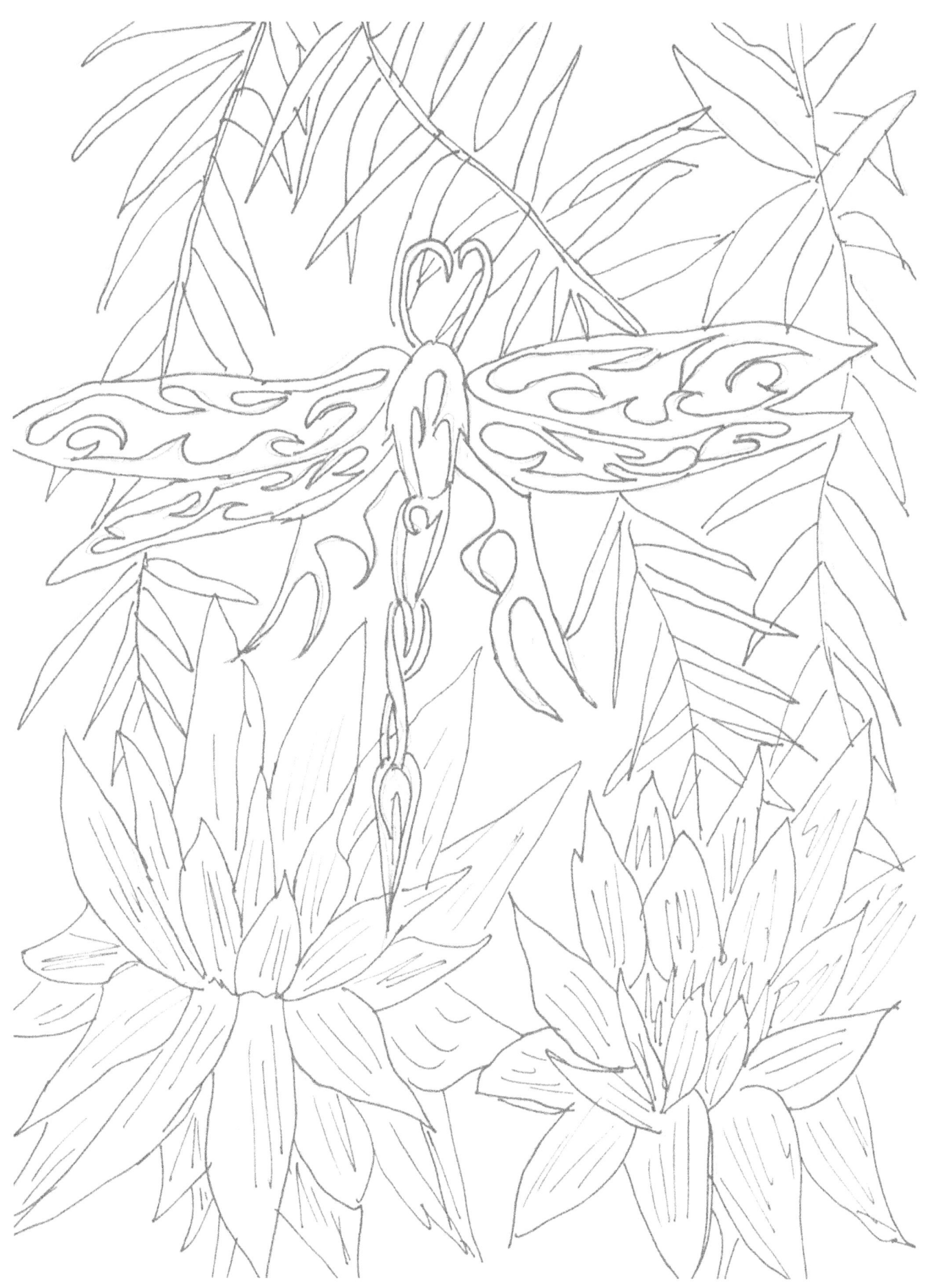

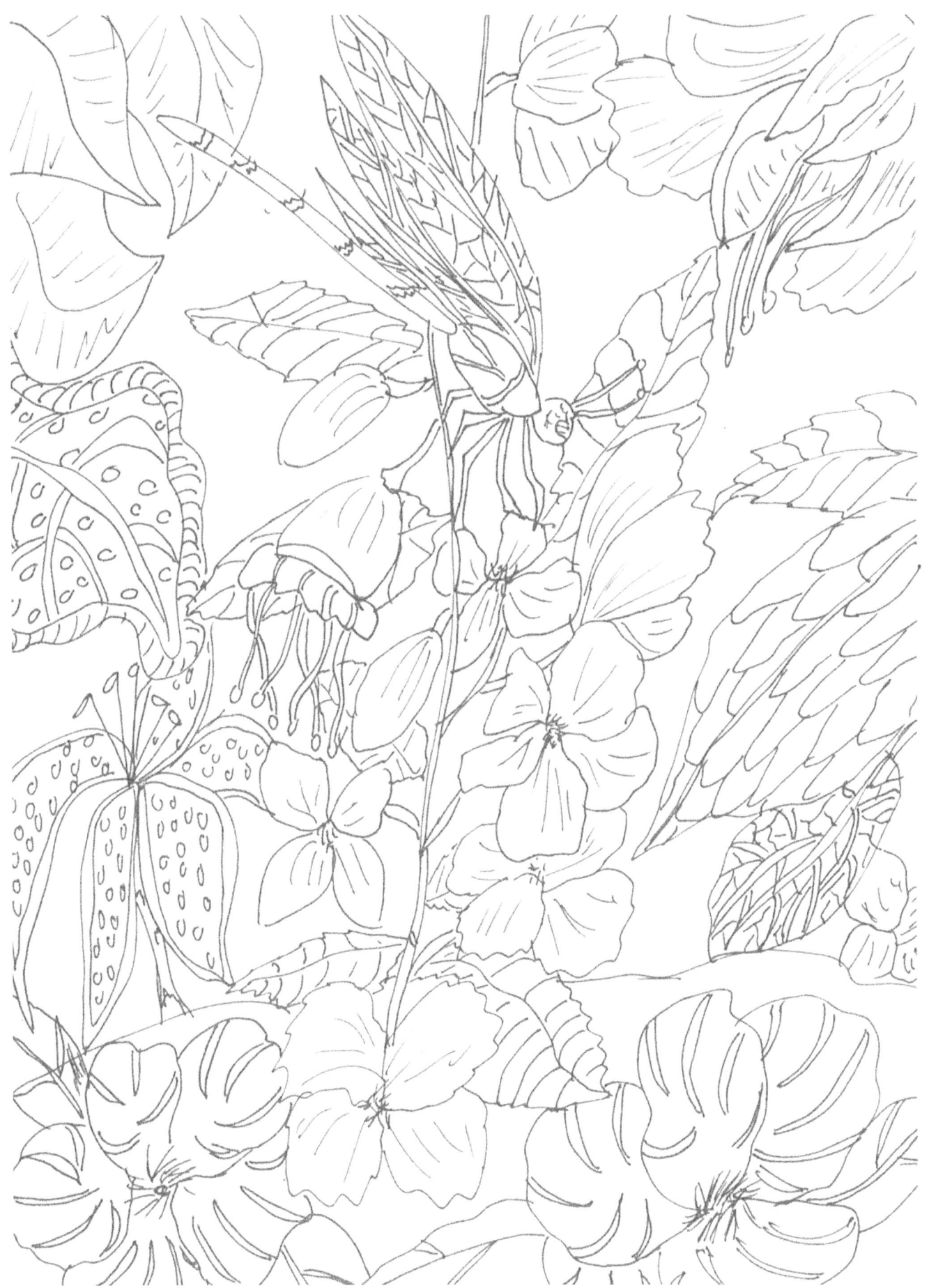

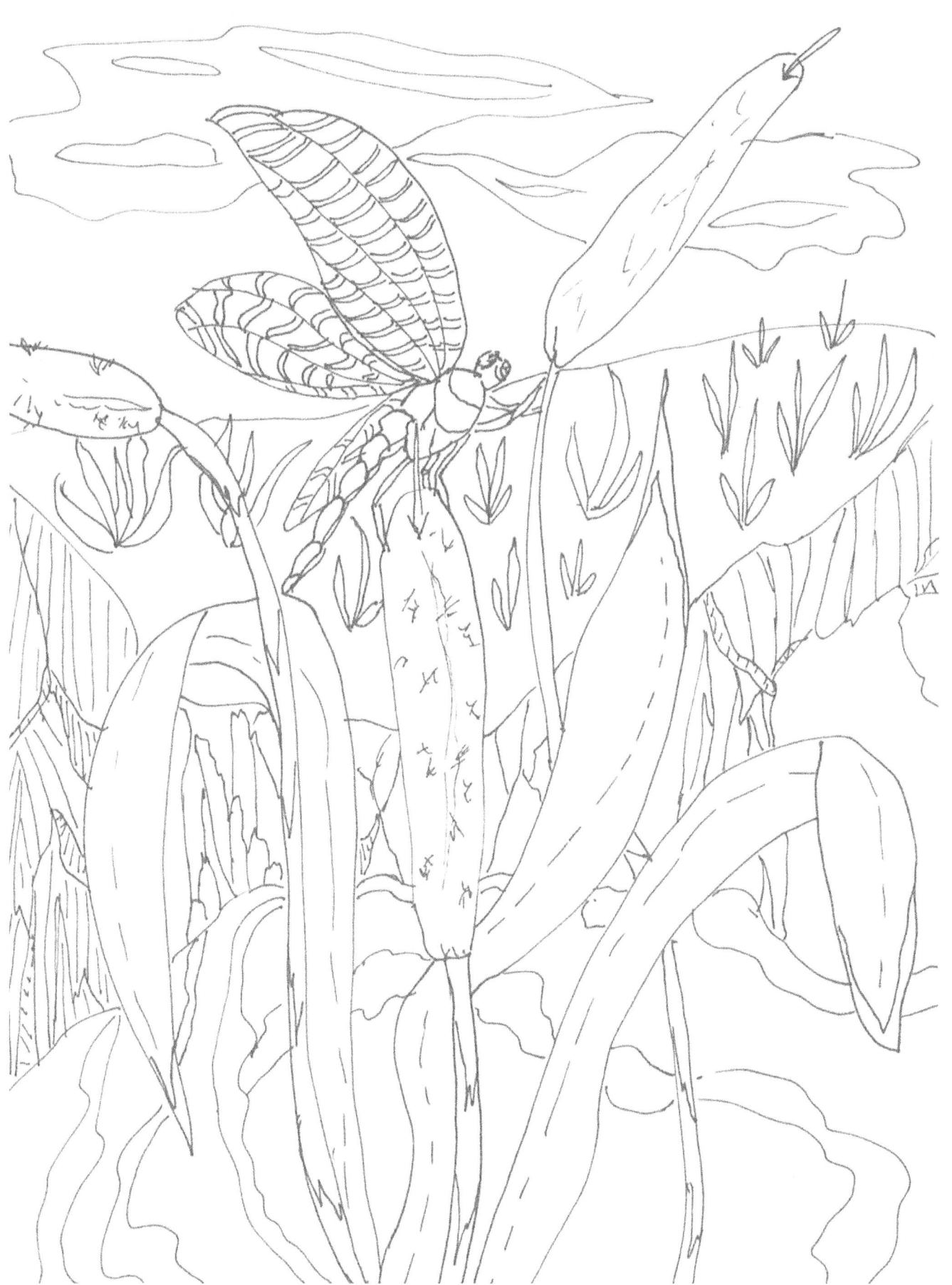

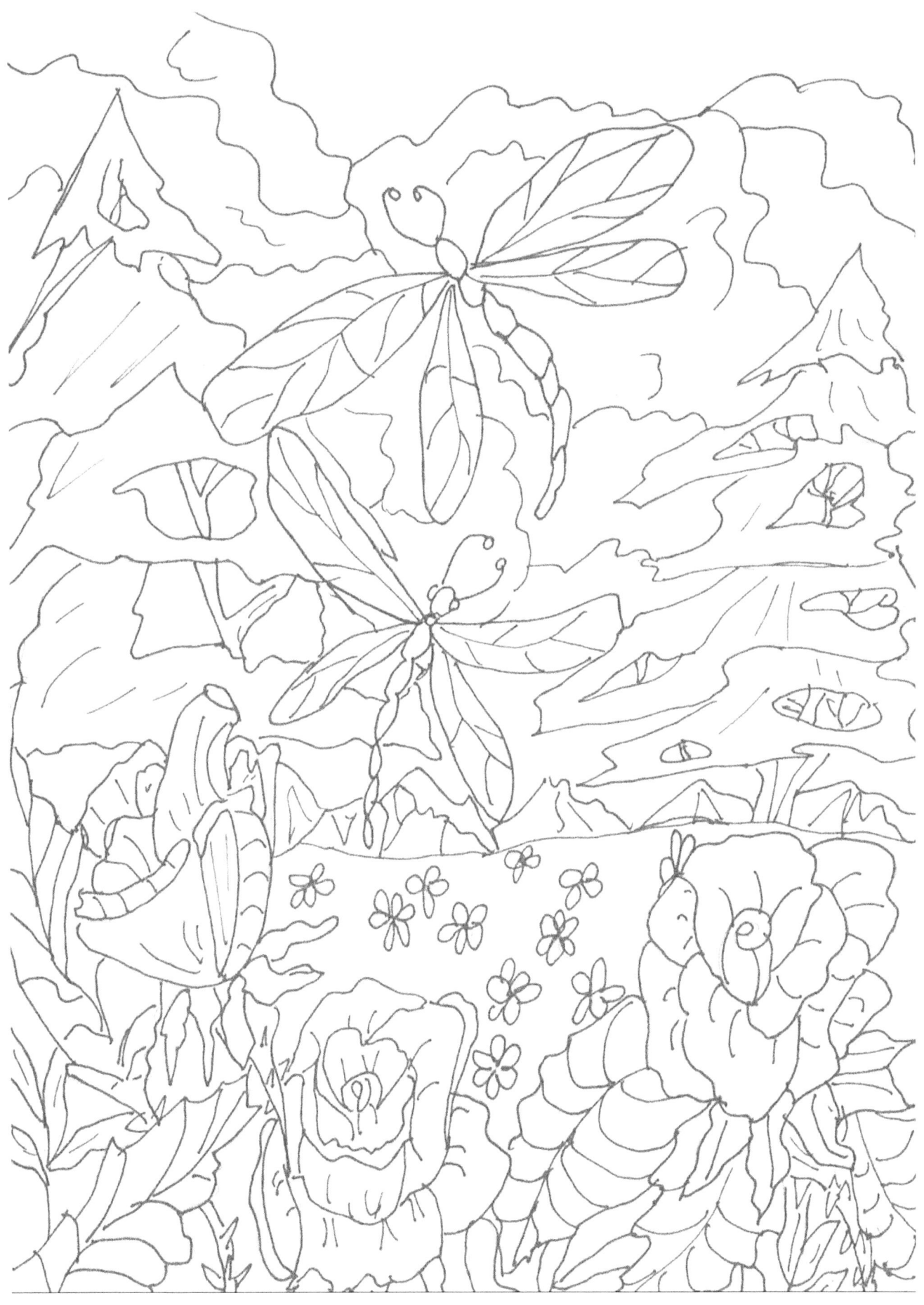

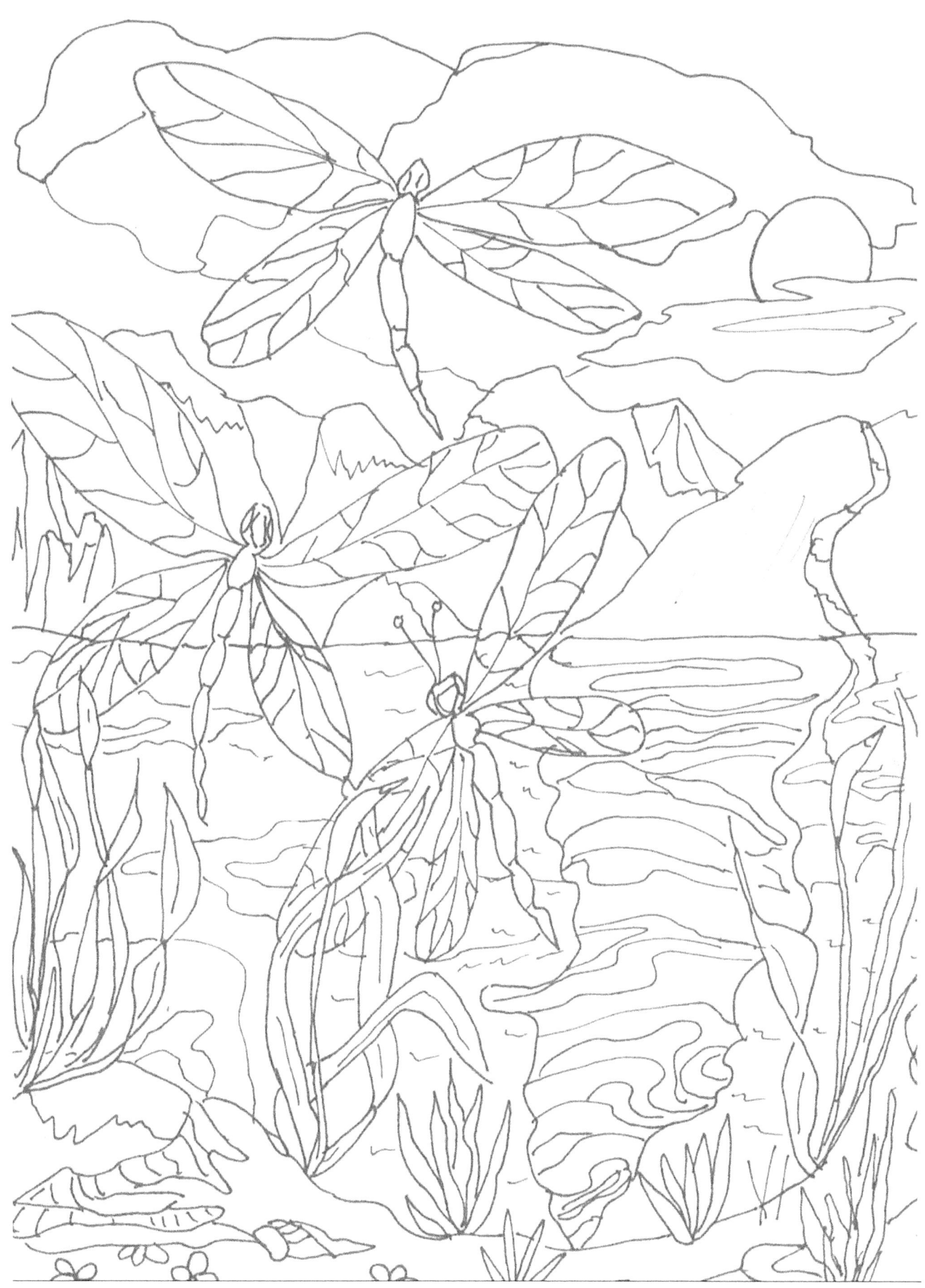

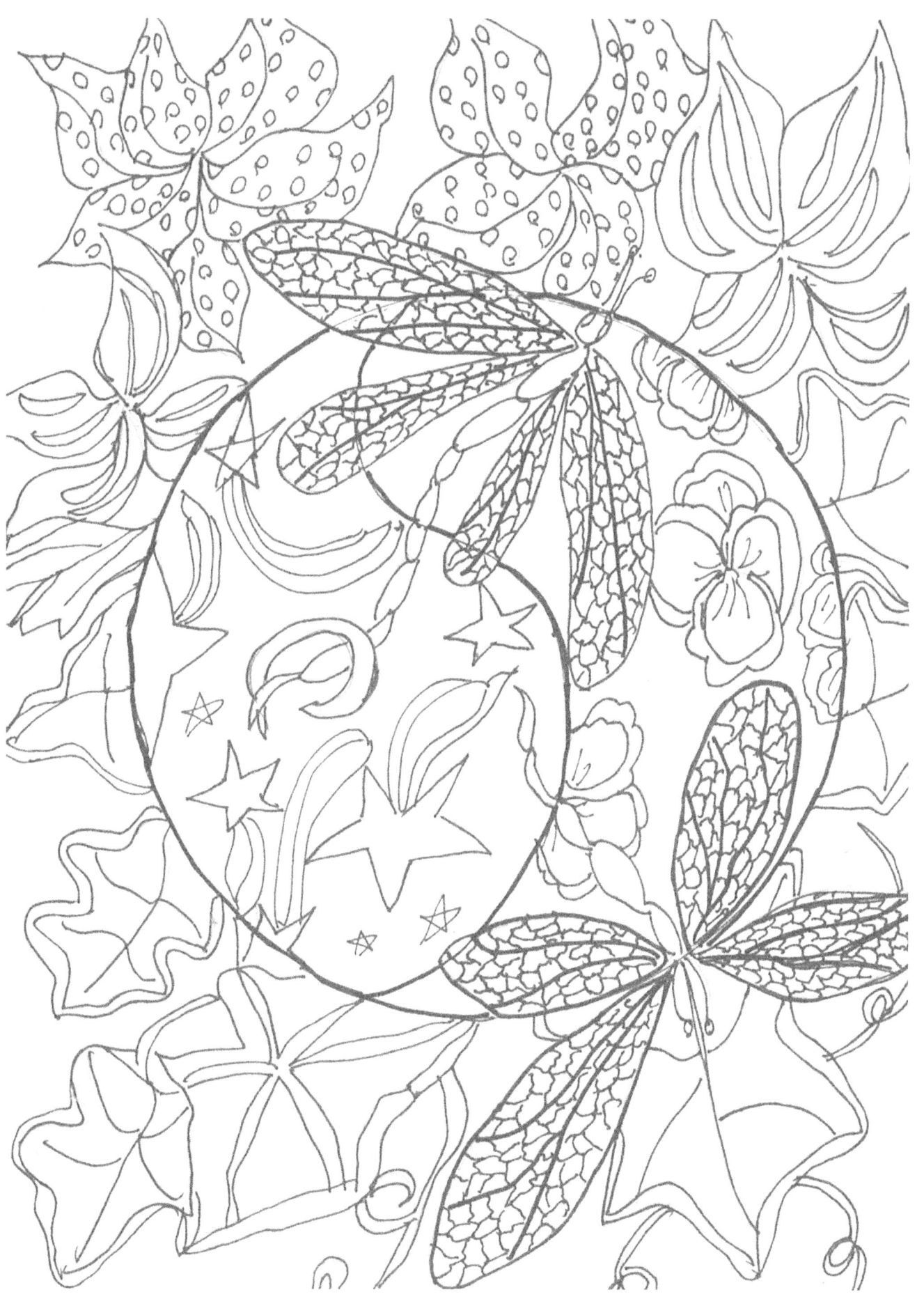

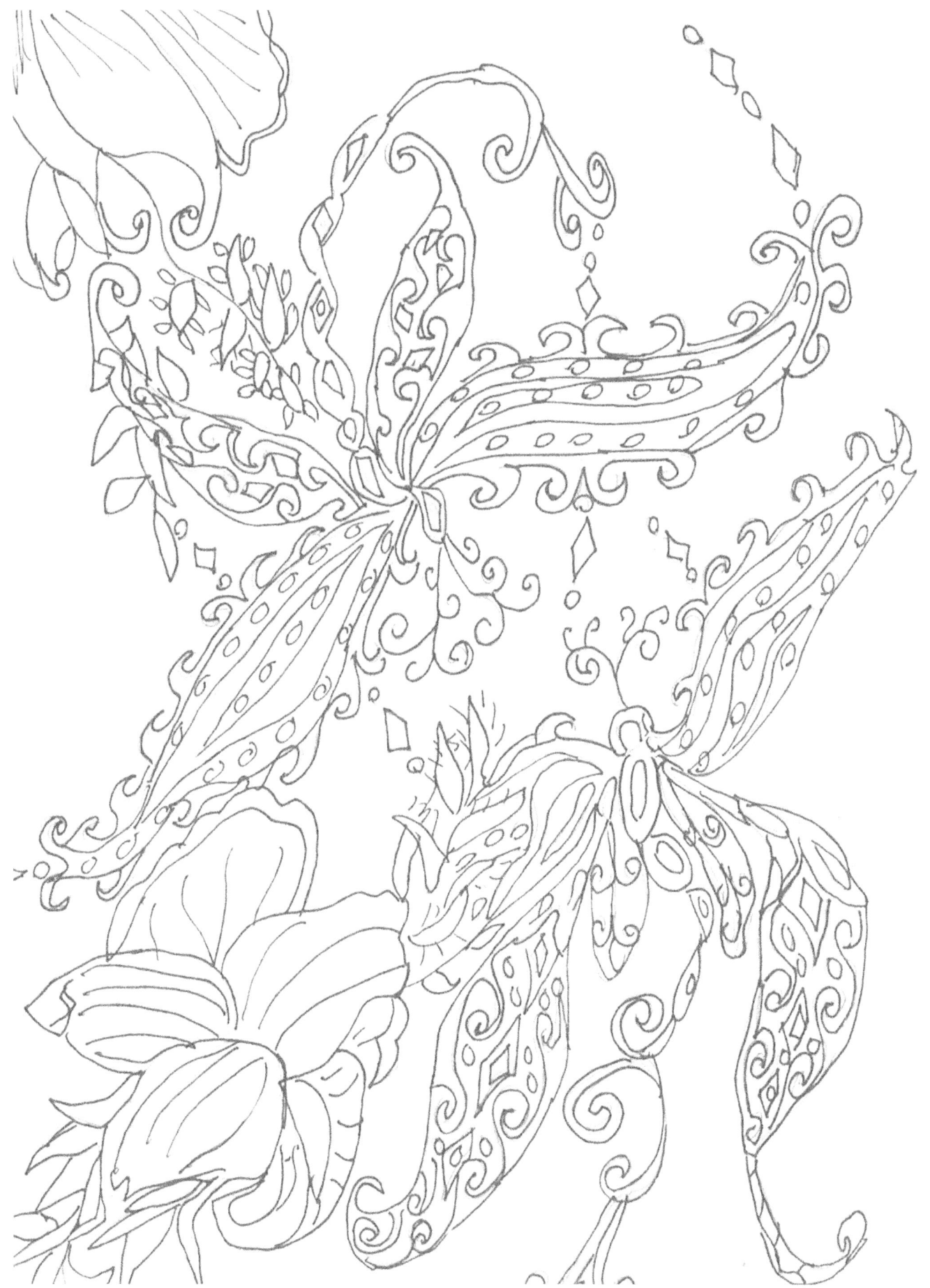

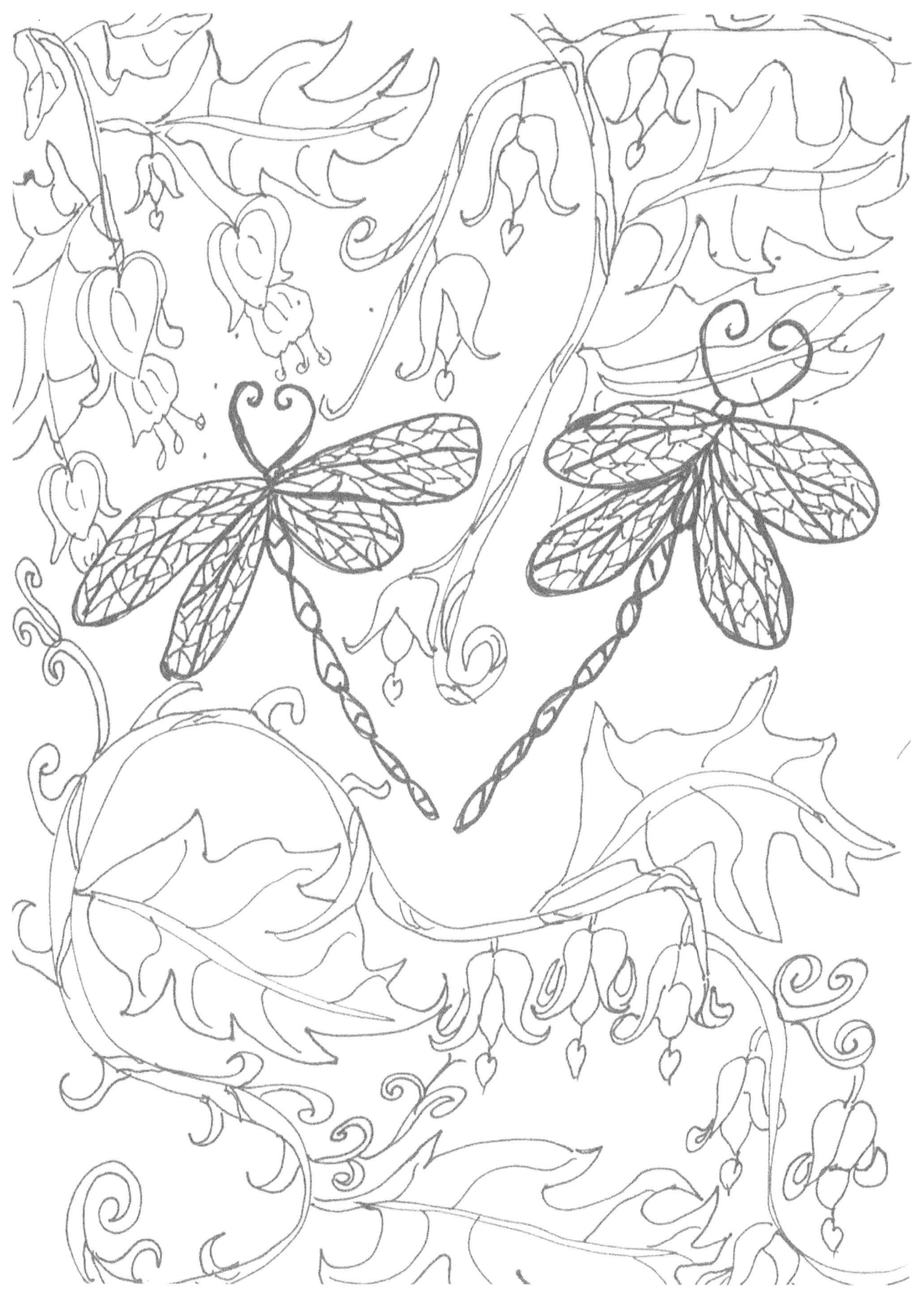

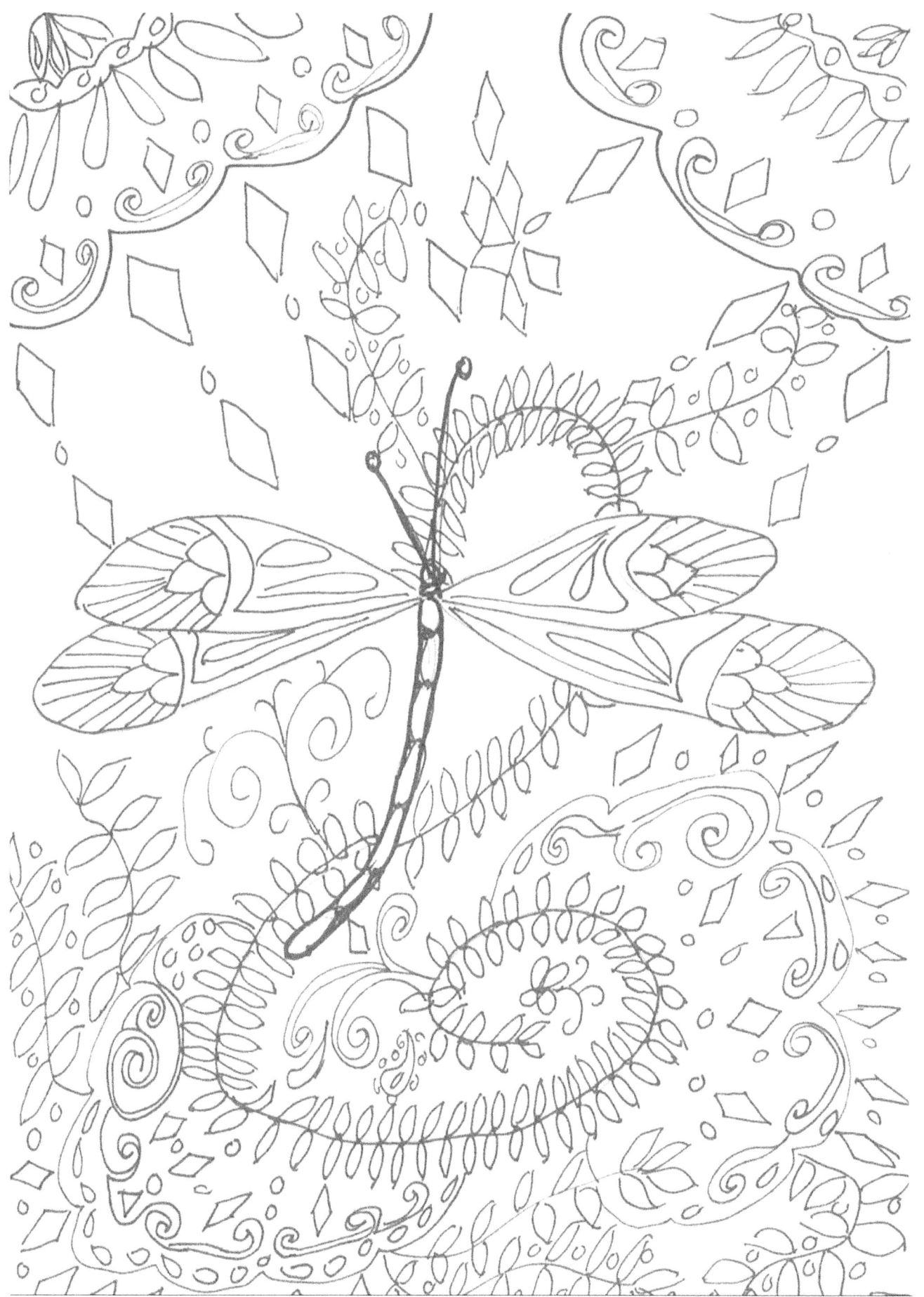

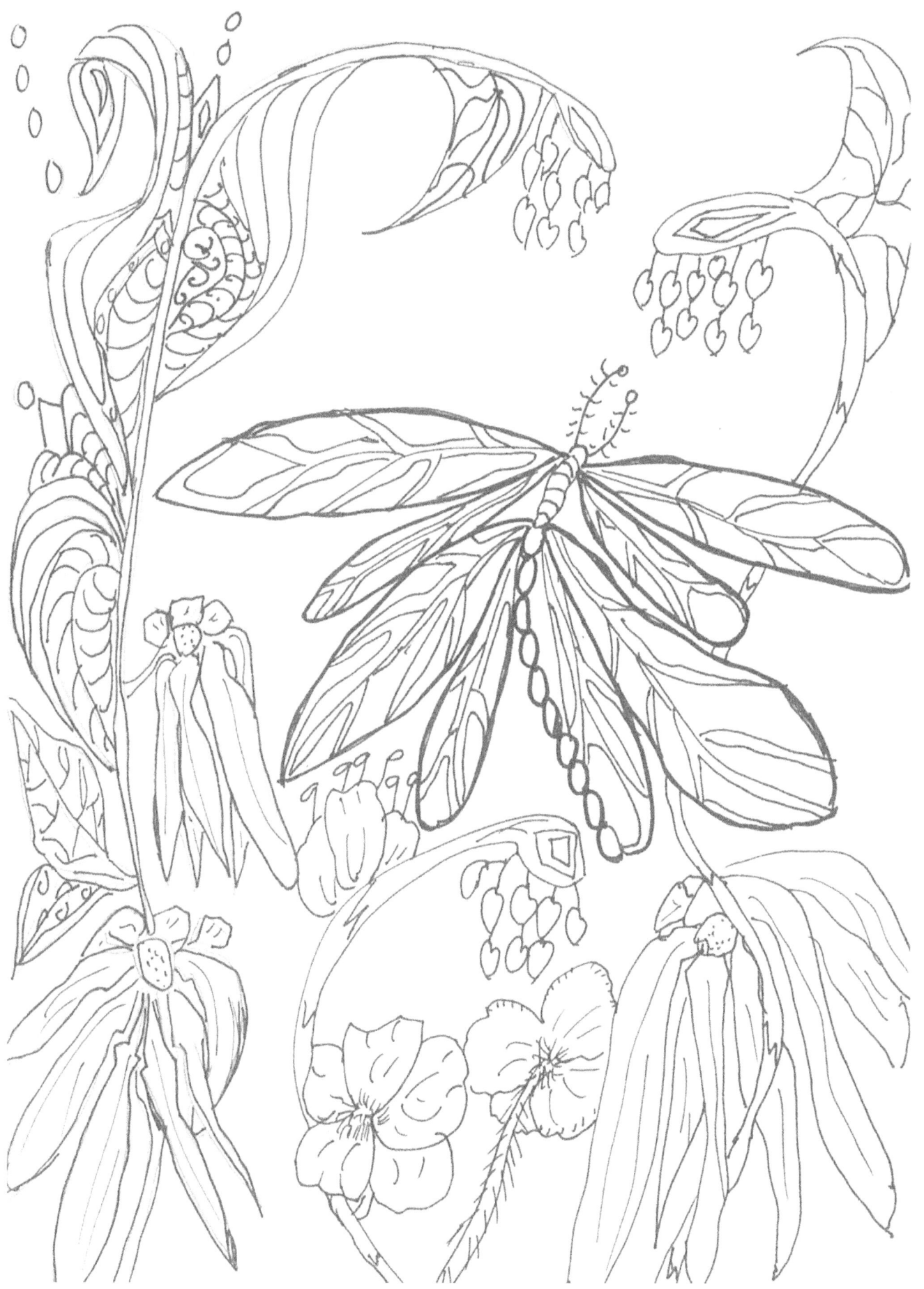

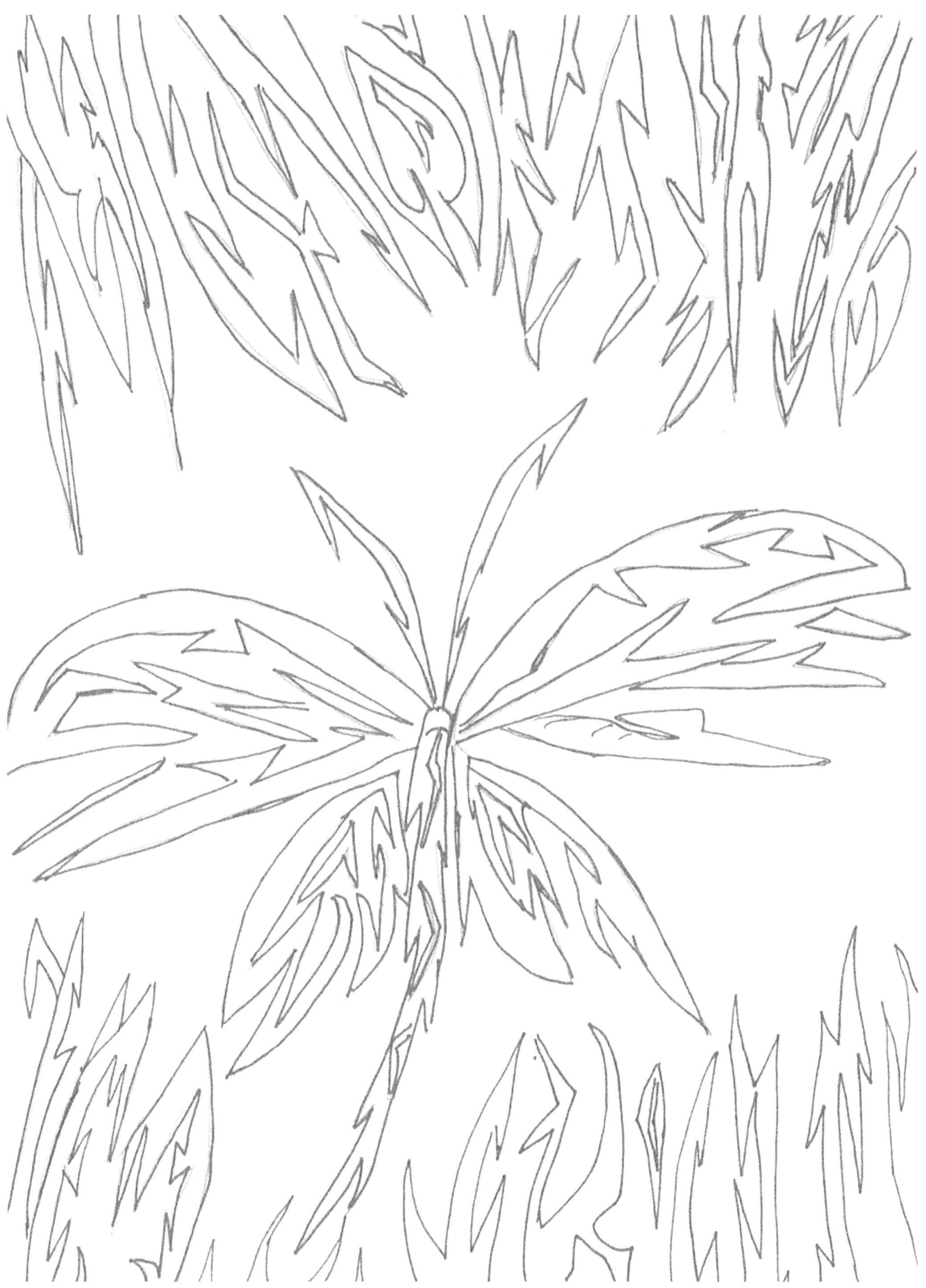

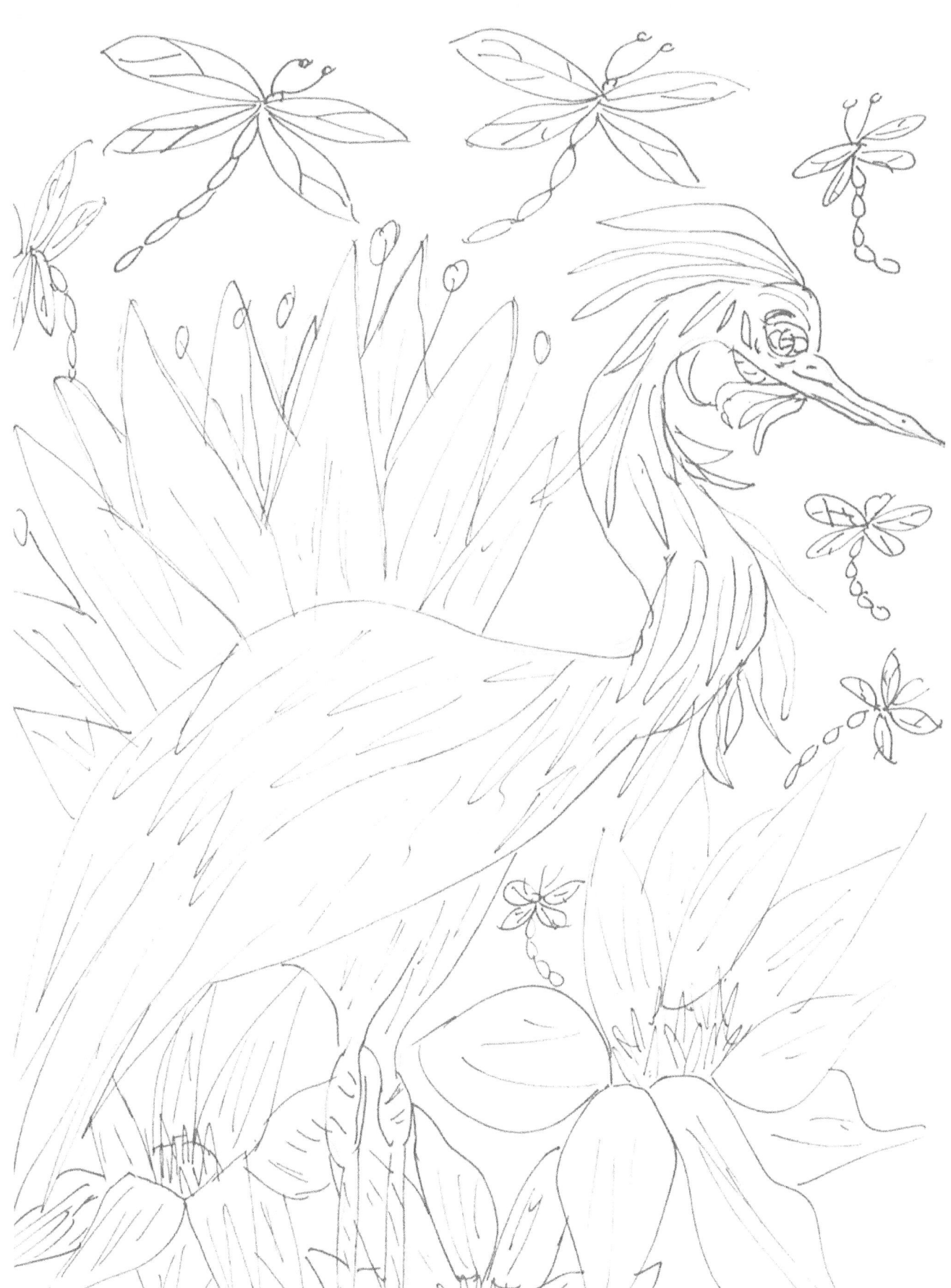

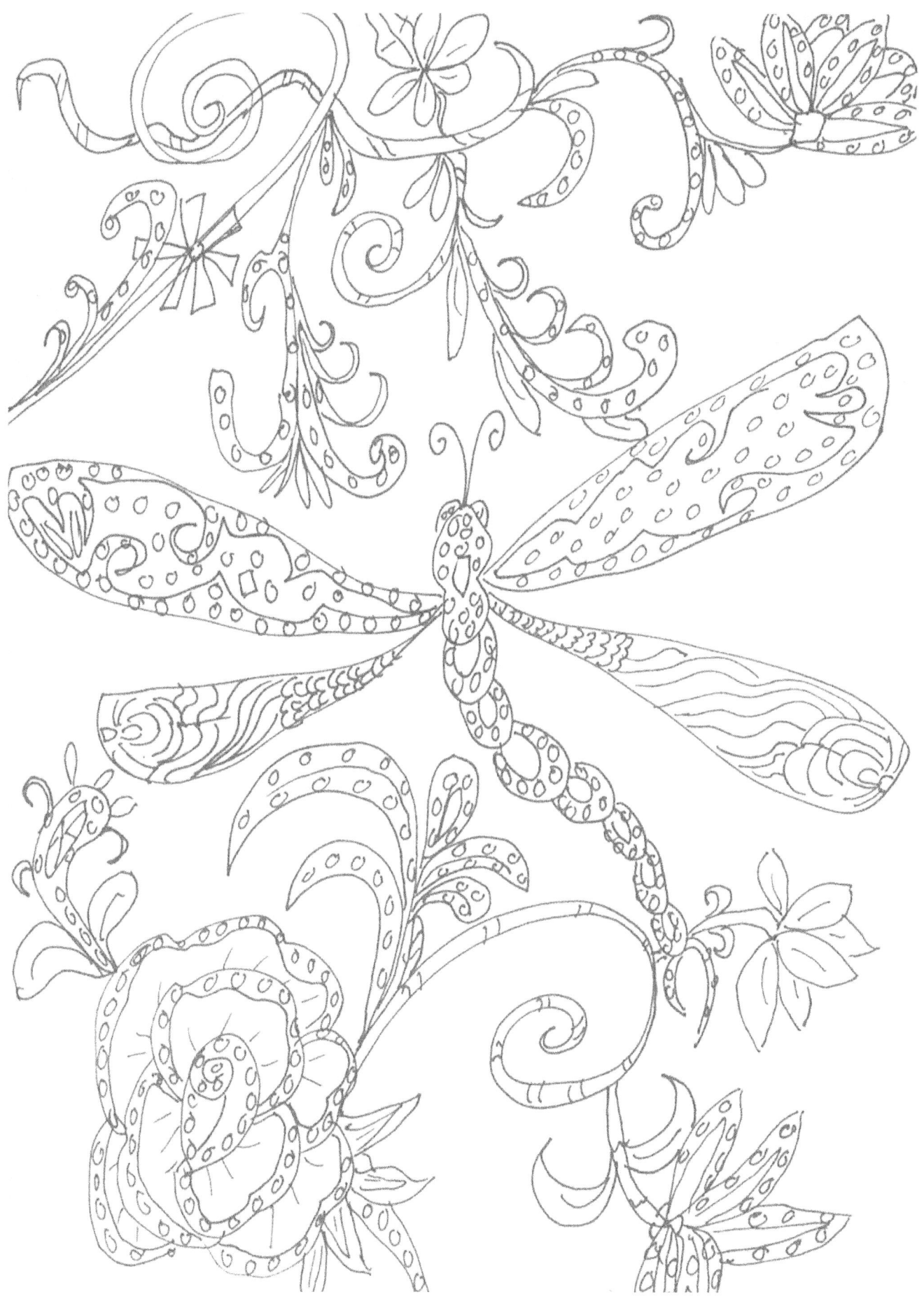

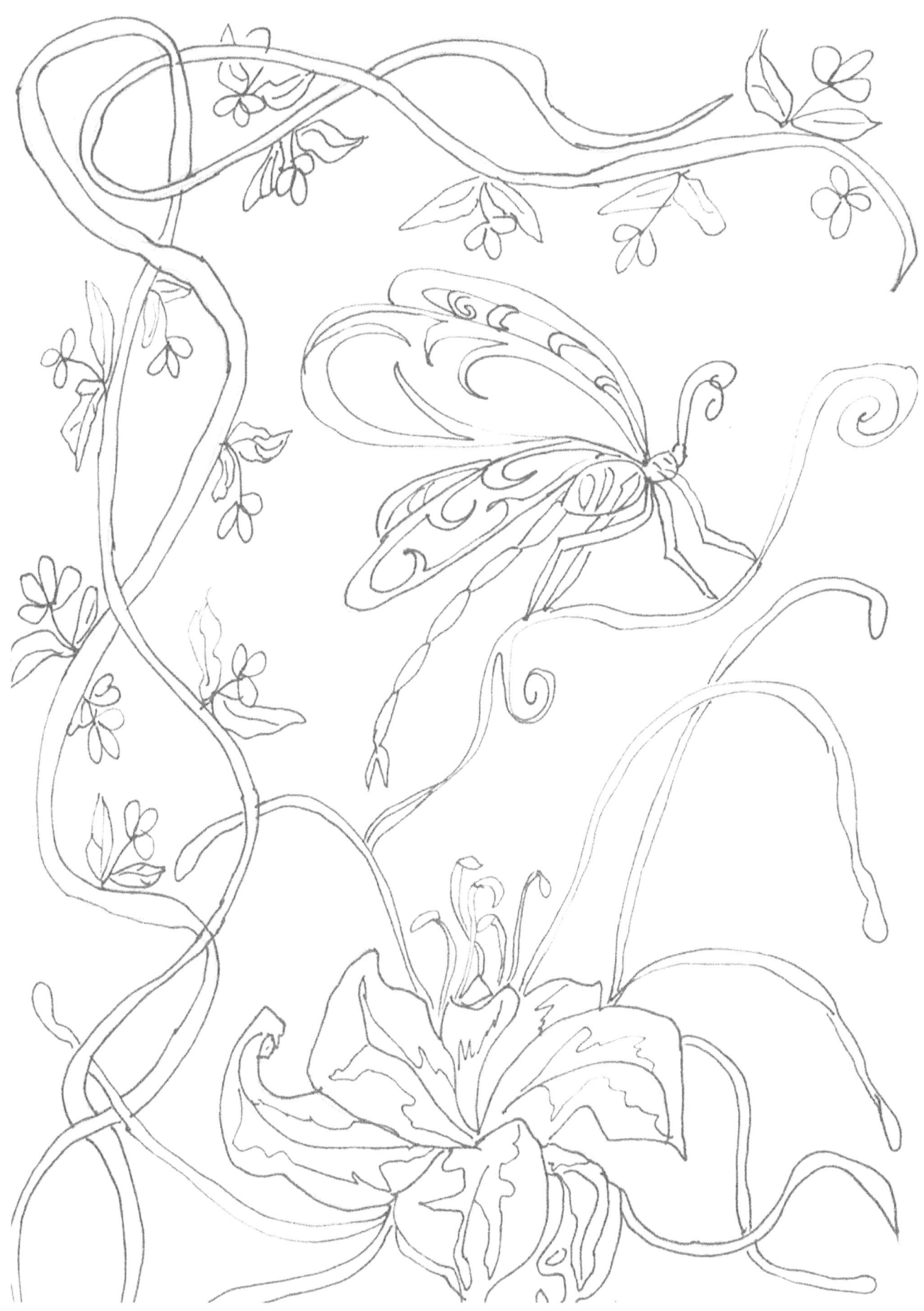

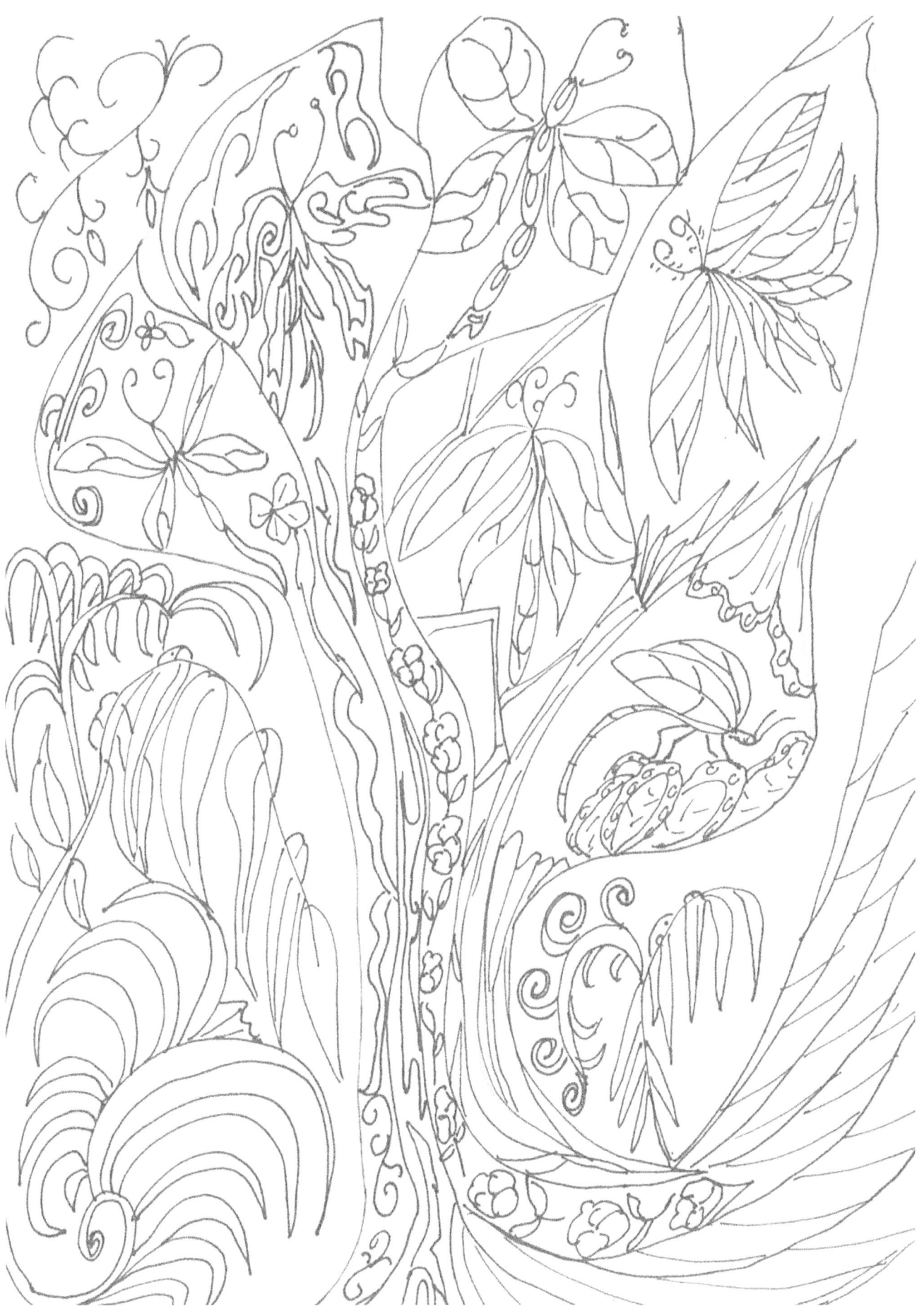

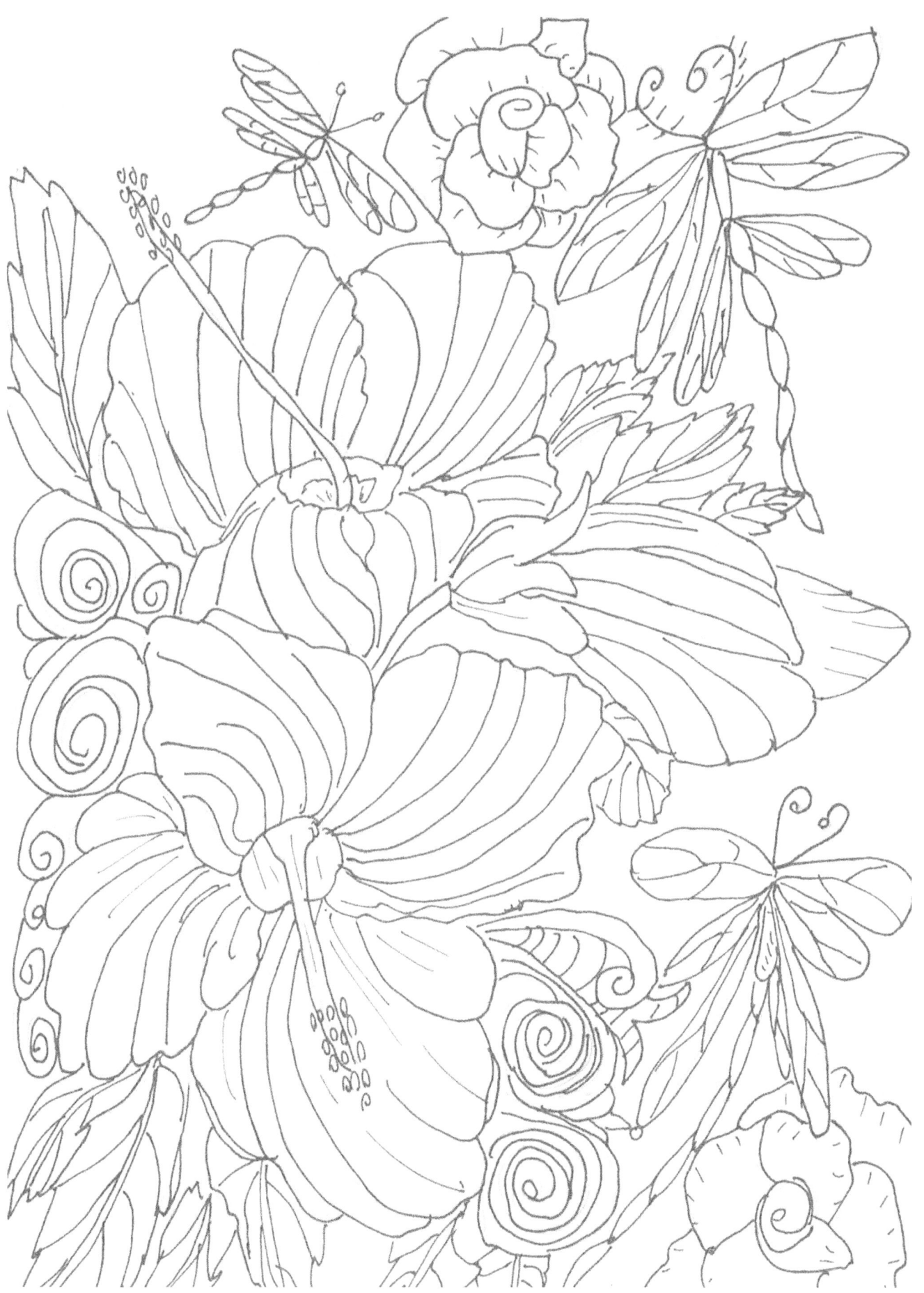

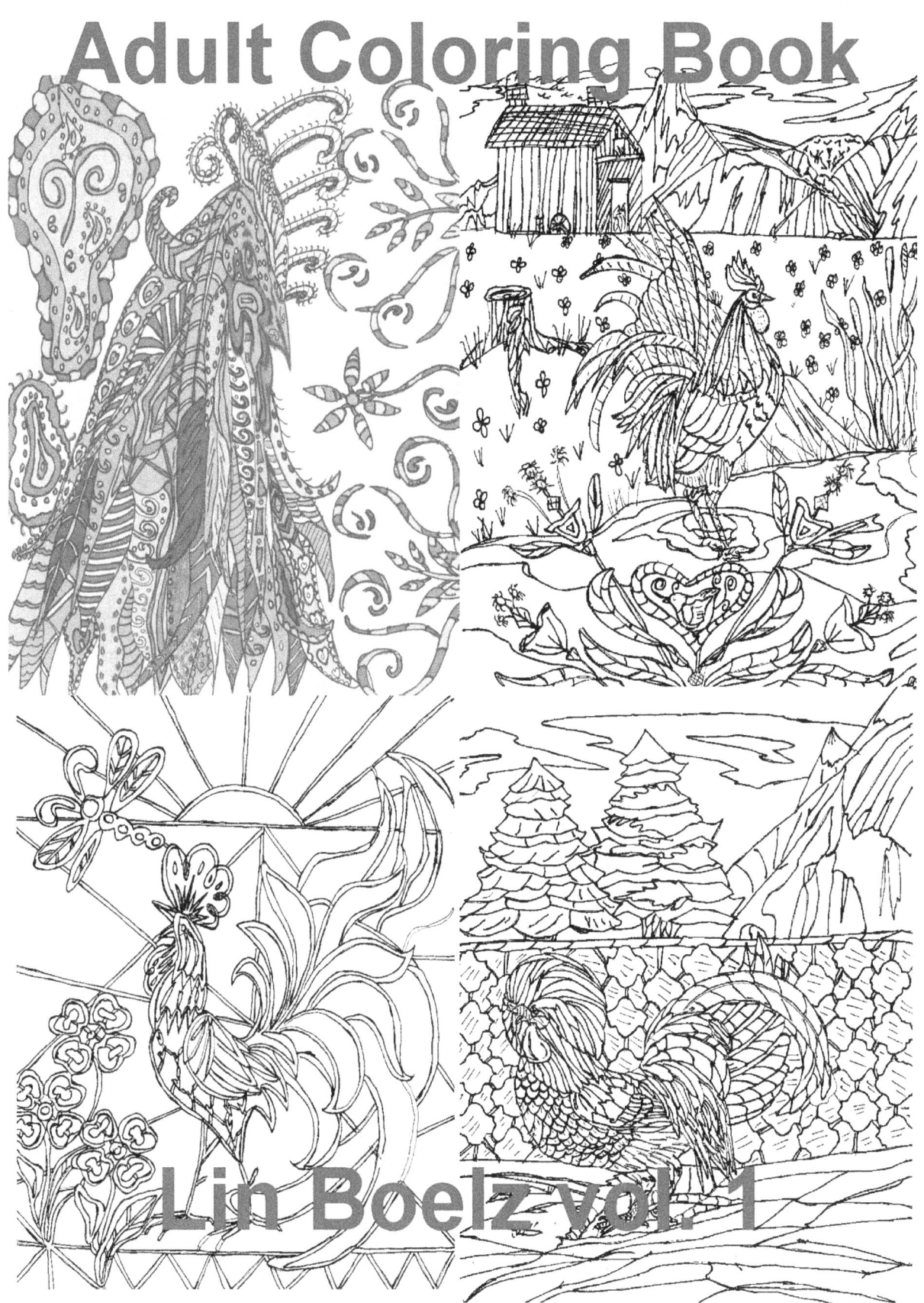

Adult Coloring Book South West & Floral Vol. 2

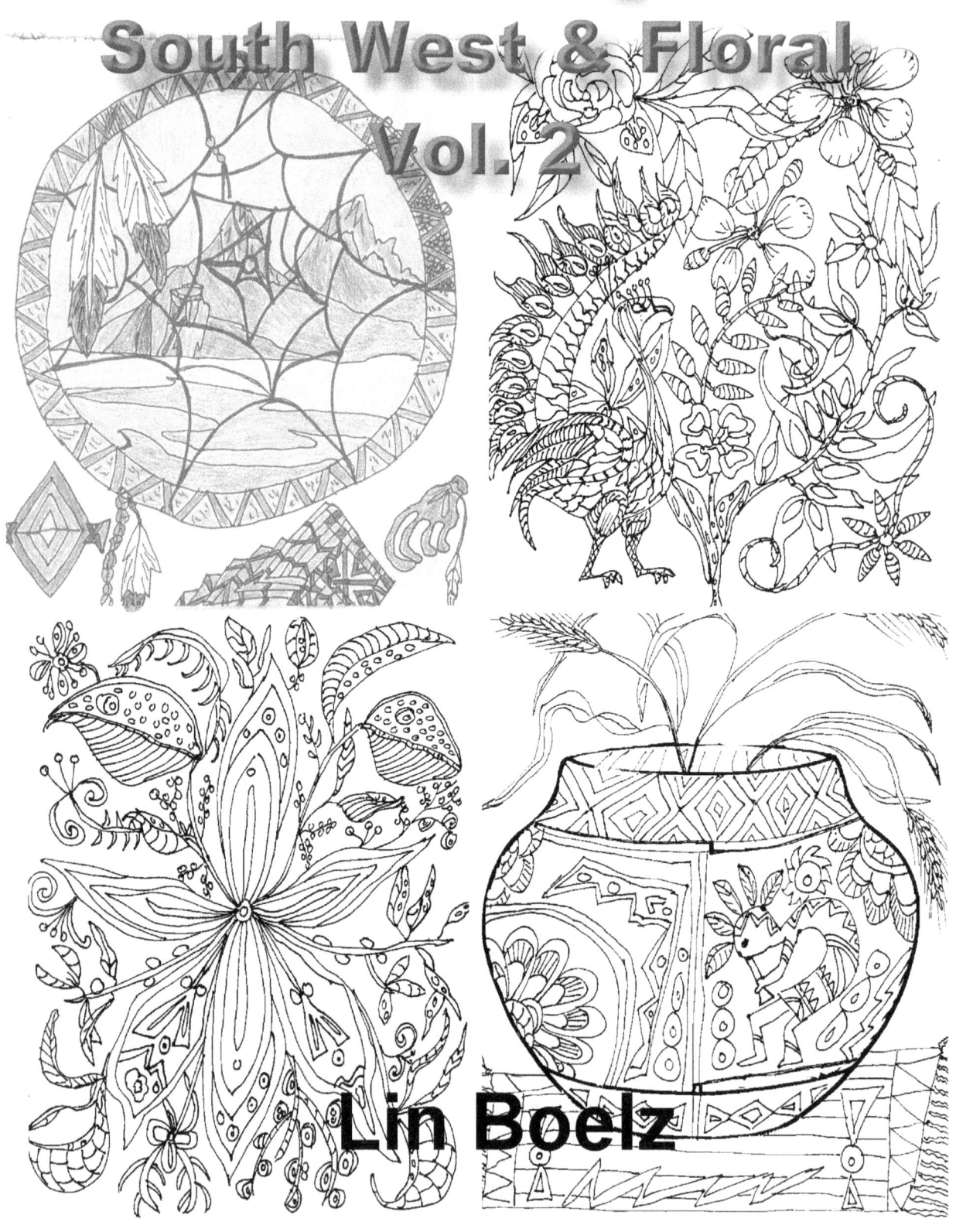

Lin Boelz

Day of the Dead & Mardi Gras Vol. 3

Lin Boetz

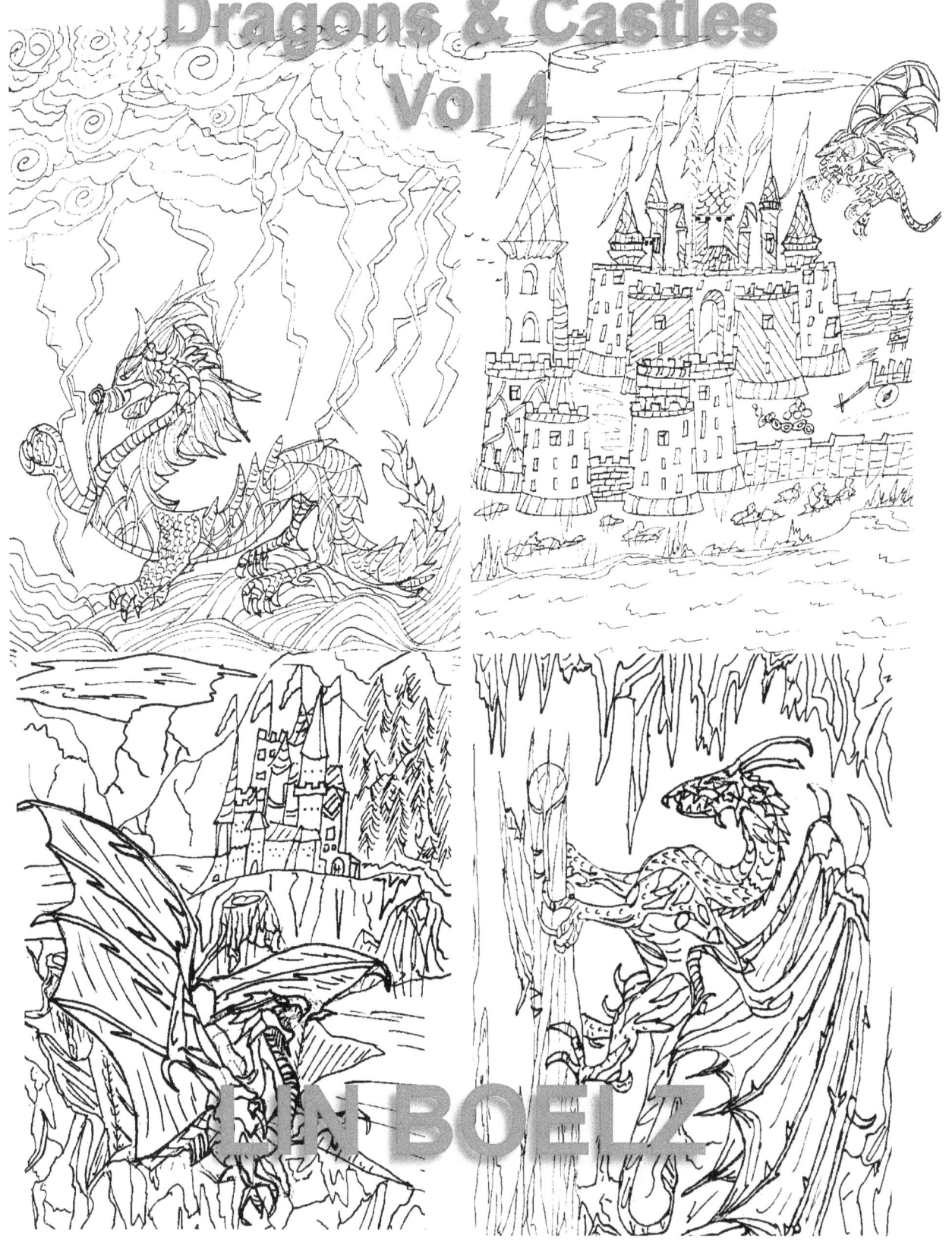

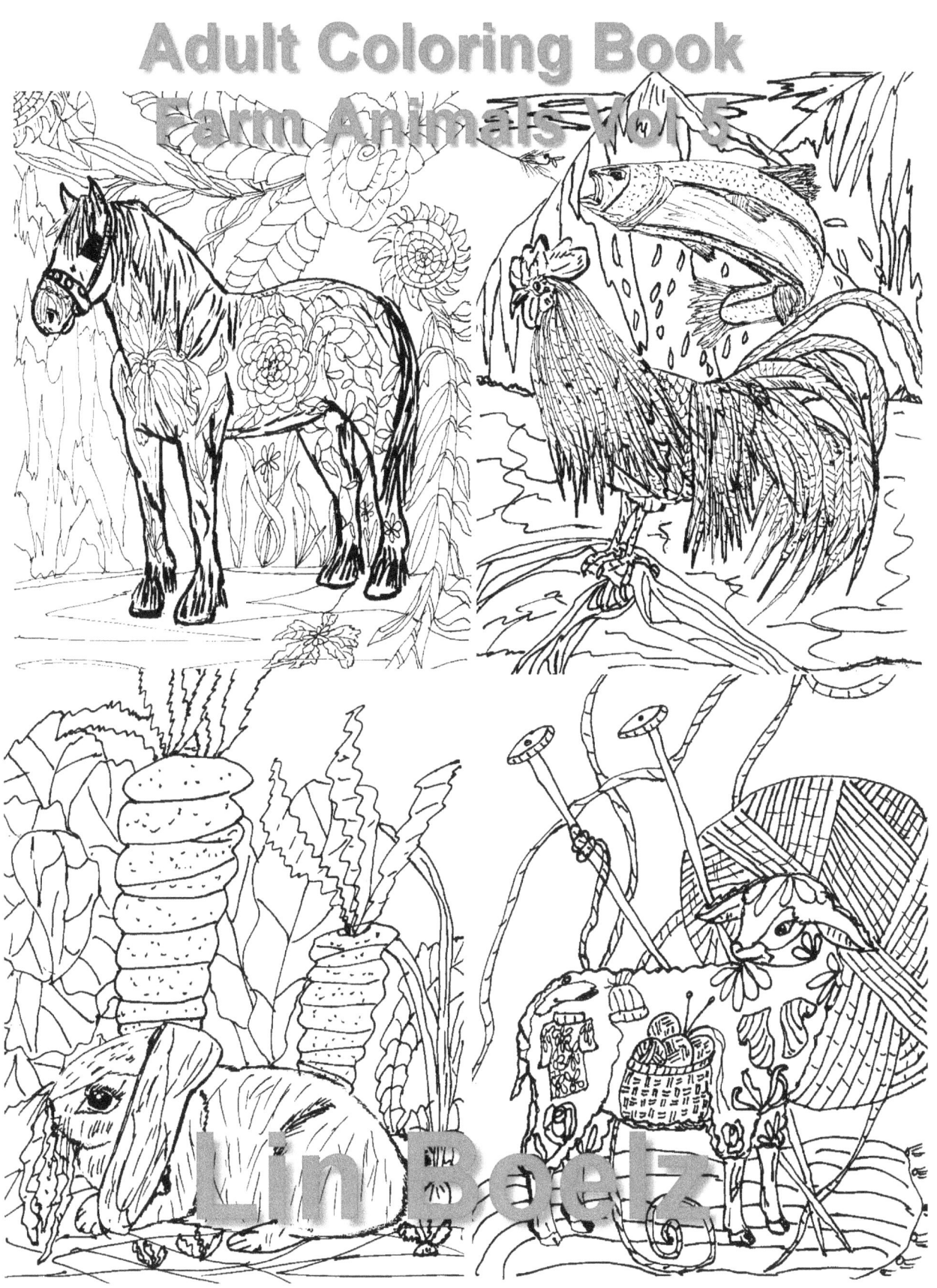

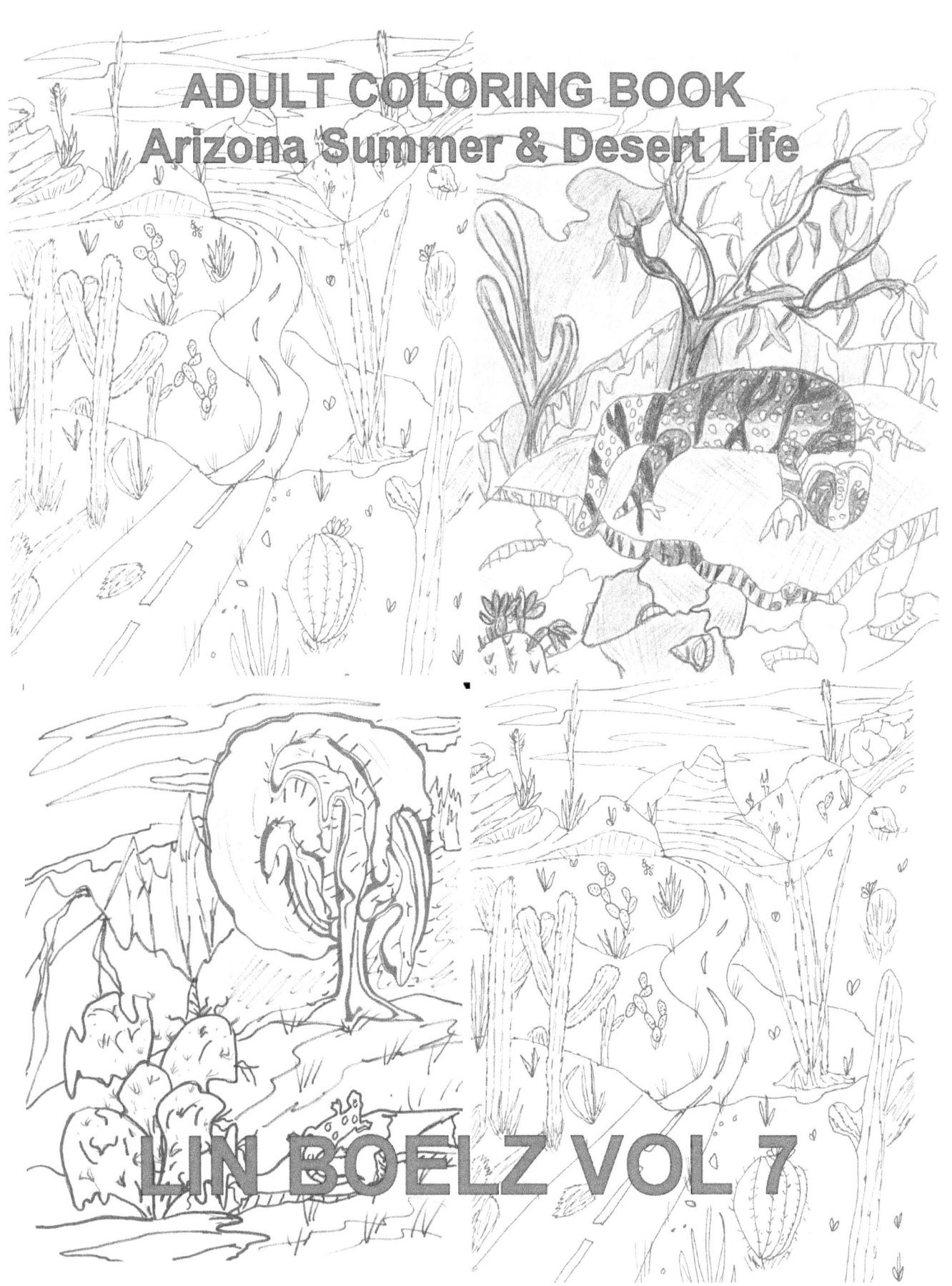

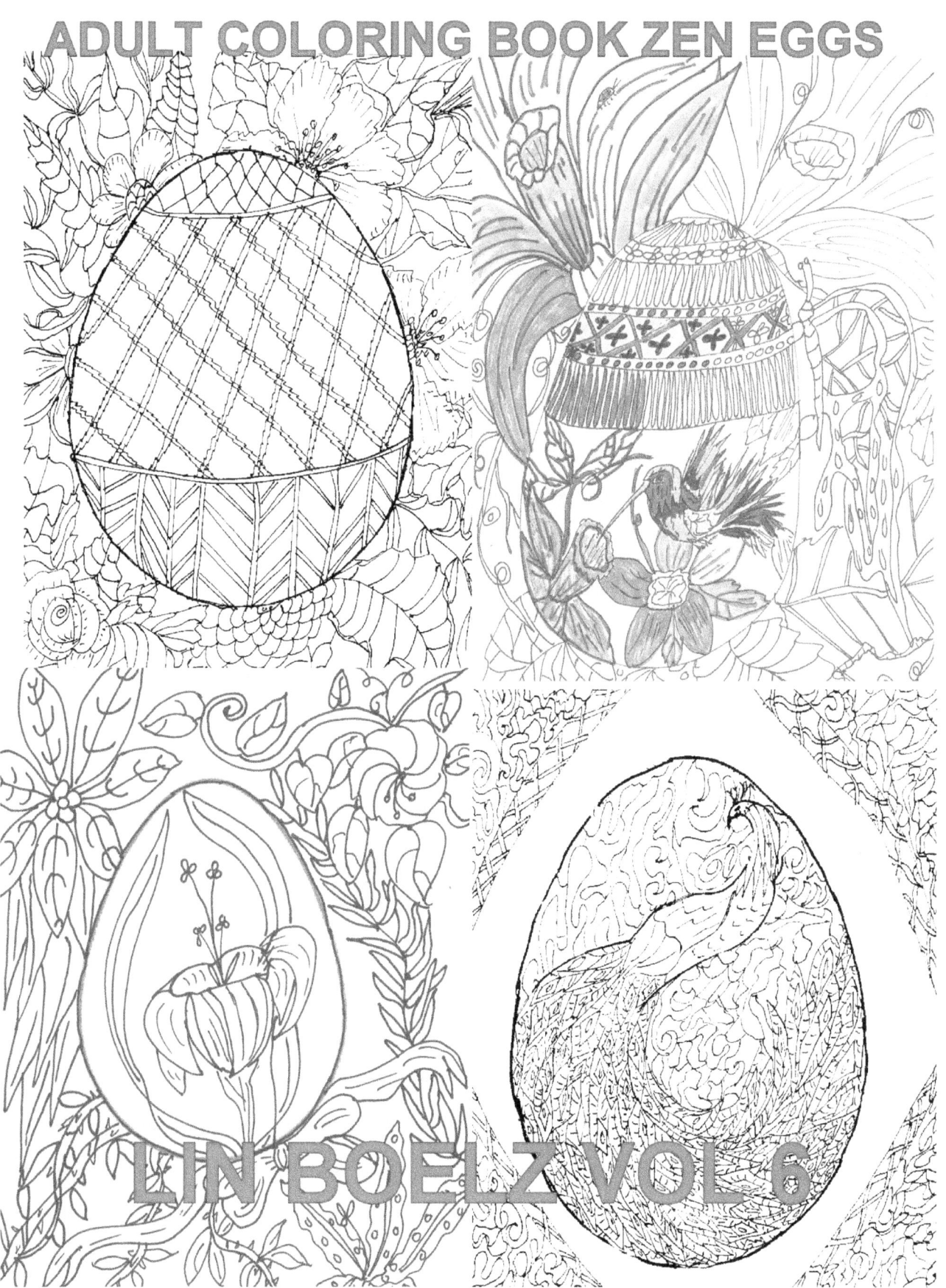

www.ingramcontent.com/pod-product-compliance
Lightning Source LLC
Chambersburg PA
CBHW080606190526
45169CB00007B/2898